# FURTHER STEPS IN
# OIL PAINTING

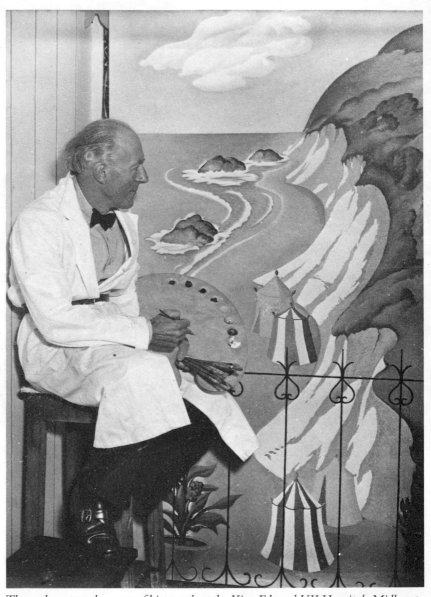

*The author at work on one of his murals at the King Edward VII Hospital, Midhurst, Sussex*

# FURTHER STEPS
# IN
# OIL PAINTING

written and illustrated by
## ADRIAN HILL

P.P.R.O.I., R.B.A.

## BLANDFORD PRESS

POOLE          DORSET

*First published 1970*
*Copyright © 1970 Blandford Press Ltd*

*Link House, West Street,*
*Poole, Dorset BH15 1LL*

*Reprinted 1976*
ISBN 0 7137 0521 3

To EVELYN HARDY

Printed in Great Britain by
Butler & Tanner Ltd
Frome and London

# Contents

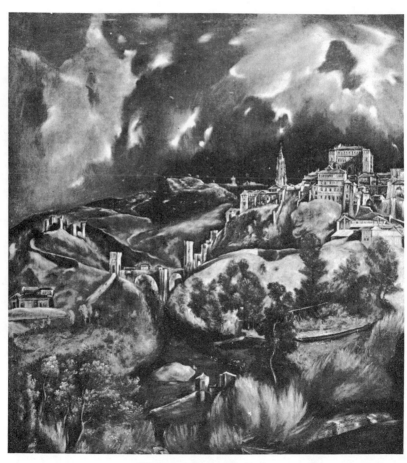

*El Greco: View of Toledo*
*One of his rare landscape paintings*

# Introduction

At the request of my publishers, this new work is offered as a sequel to *The Beginner's Book of Oil Painting* with the hope that it will prove of further help to the advancing student. The title is self-evident, for once the beginner has got off to a flying start, unexpected difficulties will be encountered, which, unless they are explained, may daunt his spirit of adventure and even convince him that he has not, after all, the ability to make good his early hopes of success.

In many cases I believe it is only a matter of retracing his steps and going over some of the preliminary ground, for it must be admitted that, as in other activities, there is such a thing as 'beginner's luck', and it is well worth the time, trouble and patience to consolidate what has not been assimilated but achieved by chance, and thus proceed with renewed confidence. Here I am reminded of two conversations, both with friends who are amateur artists.

The first, a London business man, explained that while he could hardly wait for the weekends to get back to his painting, he had recently 'got stuck'. 'You know, I find colour mixing still very difficult; my results don't seem to improve,' he naïvely explained. He also confessed he was hopeless at drawing. To my friend, and I imagine many others like him, drawing was not all that important. It was the painting that fascinated him.

In the second instance, I had not seen my friend or his paintings for some years. He produced a recent effort for my criticism, or, perhaps, benediction, with the usual excuses for any slight defects in drawing or composition. His concern was over the colour scheme. Right in the middle of his picture was an ancient church set in a varied landscape of trees, deciduous and evergreen, surrounding a meadow which occupied the foreground, and everything – except the church – appeared to be painted with one metallic green. I felt some constructive criticism was necessary. It was a social occasion, so I merely whispered, 'Aren't your greens all on the cold side?' He looked anxiously at his painting. 'You

know,' he admitted generously, 'you're dead right, now I come to look at them. I'm not so hot on greens.' And he was dead right – he wasn't even warm!

Both my friends were perhaps in need of 'further steps', for surely it is of some consequence that we know more about colour, what the pigments are, the many and varied results which can be obtained by judicious mixing, and still more (for many students a lot more) about composition and its indispensable part of a painting's success.

Such a critical overhaul having been found necessary and beneficial, our further steps should include an occasional change of subject-matter and certainly regular pauses for serious experiment in personal approach and handling, based on the knowledge that only by such methods of trial and error can real progress be maintained, and the lurking danger of adopting a well-tried formula be avoided. A slavish regard for traditional precepts can lead to a desire to break out and even paint 'dangerously'. I have indicated in the following chapters when and where such enterprise and freedom of expression may be enjoyed.

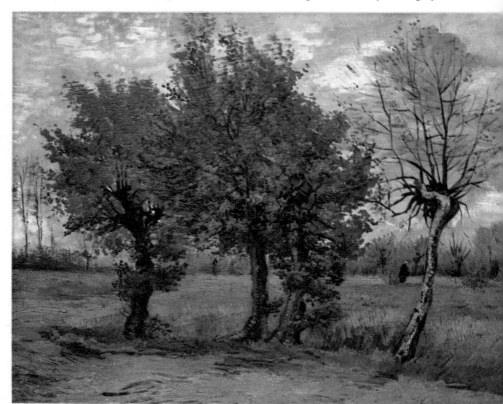

*Van Gogh: Autumn Landscape with Four Trees*
*An example of a formal landscape, with the artist's characteristic prediliction for yellow*

# 1 The importance of colour

## Colour vision

The reader may only just have started painting or he may have been practising for a month or a year without realizing that something is wrong with the result of his colour schemes when compared with those of his contemporaries. In a book of this kind in which colour is the main object, it is not out of place to mention colour-vision defects, for such do exist and have to be sorted out.

Professor R. W. Pickford points out that, 'Since there are about 9 per cent of men in this country who have a red-green colour defect and about 1 woman in 250, the problem of the influence of such defects on the art of their paintings may be considerable.'

This does not necessarily mean that all colour-defective art students ought to be detected and told of their defects or excluded from schools of art, and those with artistic talent should stick to engraving or black and white work, for it has been proved that they do not do so and that a gifted artist who has a colour-vision defect may well set a style for certain trends in colouring which may become traditional and be accepted by other painters whose colour vision is normal.

El Greco, for example, could be quoted as a great painter who, like Léger, suffered from a colour defect, pseudo yellow-blue blindness. More to the point in the context of this book is the question of beginners, or amateurs, who may not be aware of – let us call it – an apparent colour insensitivity. In these cases, it is a matter of training the eye to distinguish between numerous variations in tint and tone so that one's colour vision is refined and *enlarged* rather than *corrected*.

In short there is nothing to prevent the development of the discriminating eye through which the practising painter views Nature, except for those unfortunate few who are found to be colour-blind.

And while there are no rigid rules which define the exact shade of grey which must appear beside a certain shade of black, there is an eternal law which 'thunderously condemns as unhallowed the marriage

of mauve and magenta'. Not to mention the fierce hostility to the sensitive eye of puce and vermilion! In any case, a perfect arrangement of colour is something far too sensitive and rests upon a framework far too exquisite and elusive for any rough-and-ready transmutations. Nothing we come to realize, is rarer than a *perfect* eye for colour; nothing in the whole range of art is more difficult to evolve than a conclusive colour scheme. But that should not deter us from making the attempt.

## Colour and the world around us

When we stop to think about colour and its true significance and importance to the painter, we must surely realize at the same time how colour has become more and more woven into the very texture of the lives of all of us. Without colour in Nature, in beasts, birds and fishes, in human beings and the clothes we wear, in our home surroundings, in the very food we eat and in our various places of work and play – in short, in existence as we know it, life would be drained of that quality and vitality which gives it its very meaning.

Ruskin is more evocative on this subject when he writes: 'The fact is, we none of us enough appreciate the nobleness and sacredness of colour. Nothing is more common than to hear it spoken of as a subordinate beauty – nay, even as a mere source of sensual pleasure. If the speakers would only take the pains to imagine what the world and their own existence would become if the blue were taken from the sky and the gold from the sunshine and the verdure from the leaves and the crimson from the blood which is the life of man. The flush from the cheek, the darkness from the eye, and the radiance from the hair – if they could but see for one instance white human creatures living in a white world, they would soon feel what they owe to colour. The fact is that of all God's gifts to the sight of man, colour is the holiest, the most divine, the most solemn.' How true this is. As with other fundamentals in life, however, by its universal familiarity and our acceptance of it, we are apt to forget the far-reaching power and effect colour has to excite, stimulate, comfort and refresh, as well as alarm in its influence on our day-to-day existence.

## Colour preferences

All students, in my experience, soon develop a favourite colour scheme. Some combinations of colours are found to satisfy aesthetically and appeal at first sight when visiting current art exhibitions. The pleasure is immediate. The reaction is instinctive. Indeed, where famous paintings are under review, it appears that it is the colour scheme even over and above the subject which makes the picture a favourite with us.

Colour, then, could well be the determining yardstick by which we measure the success of our own paintings. It is true, of course, that as a potential painter the student may pass through a mood or period which favours certain colour combinations which can in turn be temporarily rejected in favour of a new scheme of coloration, but in the end I believe we revert to a particular range of colours which temperamentally we instinctively respond to, and this fundamental choice must be considered a valid one.

Out of some twenty colours, any painter could, I imagine, select without much hesitation their order of preference for his particular type of painting. Now, according to Professor Luscher, certain colours produce some extraordinarily complicated reactions between the retina of the eyes and the middle of the brain. Different colours even produce different physiological and psychological results. He gives as an example red quickening the pulse and heightening the blood pressure, whereas blue slows down the pulse, blood pressure and breathing. Painters, therefore, who put the reds first in their selection of favourite colours would appear to be full of desire and attack. One can certainly think of several famous painters who fit into this category. On the other hand, if the blues are favoured, the implication is an internal conflict, a striving to be calm. This may very well be true, especially of those familiar painters of a poetic turn of mind! On the other hand, blue-green, such as Prussian Blue, has been listed as an almost sinister colour, and painters favouring colour schemes in which this hue is dominant are said to suffer from tension and self-assertiveness, while those artists who have a predilection for yellow have the crusading spirit and a desire for new horizons (Van Gogh could well fit under this heading).

Brown is instanced (obviously I would think) as a colour favoured by a sombre or reflective practitioner, and here many of the Dutch landscape painters come to mind. Violet or mauve is well known to signify certain neurotic disturbances (and from my experience in the field of art therapy, it can well denote acute depression or abnormal apprehension).

Black, if dominant in a painting, is said to imply a rebellious spirit and when contrasted with white is significant of moral tensions. On the other hand, a preponderance of grey in a picture denotes a reflective turn of mind! This, I think, is fairly self-evident.

These, of course, are all generalizations and only introduced to offer some speculative theories of why a painter controls his palette and what stimulates this urge. And, in passing, it is without doubt a significant pointer that the recent increase of the low-toned painting may well have

something to do with the frustrating and ominous trends we combat in our present state of social, moral and physical instability.

In judging an exhibition of 'Young Contemporaries' some years ago my other adjudicators were agreed that there was hardly one 'happy' painting in the entire show: 'happy' in the sense of an exhilarating colour scheme, something that lifted the spirits as well as gladdened the eye.

It is, in any case, an interesting speculation to follow the natural and seemingly inevitable trend of certain colour schemes as revealed in the works of different painters, past and present, and only tends to prove the mystic or magical, or even remedial, powers that colour possesses to influence our paintings, and in some degree *our very way of life.*

Here are the palettes of two distinguished landscape painters:

IVON HITCHENS
Ivory Black,★ Burnt Umber, Mars Orange, Mars Red, Indian★ or Venetian Red,★ Cadmun Red,★ Yellow Ochre,★ Cadmium Yellow, Aurora Yellow,★ Zinc★ or Titanium White,★ Viridian,★ Terra Vert,★ Cobalt,★ French Ultramarine,★ Winsor Blue,★ Manganese Blue, Blue Black,★ Cobalt Violet, Permanent Violet, Winsor Violet.
★*In most frequent use.*

R. O. DUNLOP
Flake or Titanium White, Yellow Ochre, Naples Yellow,★ Cadmium Yellow,★ Cobalt Blue, French Ultramarine Blue, Light Red, Rose Madder, Viridian Green, Terra Vert, Burnt Sienna, Raw Sienna, Burnt Umber, Vandyke Brown.★
★ *Occasionally.*

It will be noticed that neither painter appears to use Prussian Blue, Cerulean Blue, Vermilion or Lemon Chrome.

**Painting terms**
As the student's interest in oil painting grows, he will encounter a number of perhaps unfamiliar terms which should be explained, as they are often misread, misunderstood or applied too loosely. The following list covers most of the artist's terminology:
*Pigment* The solid colouring matter produced from earth's minerals or inorganic salts and classified under Permanent, Fugitive, Opaque, Transparent.
*Primary Colours* Red, green and violet. With painters, red, yellow and blue.
*Hue* Used in place of colour.

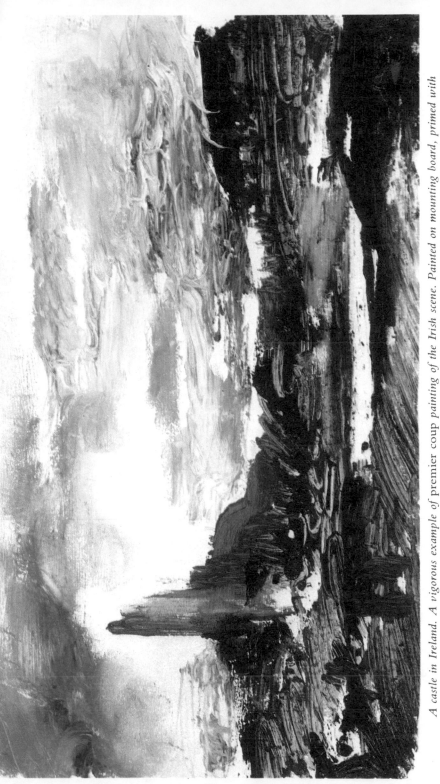

*A castle in Ireland. A vigorous example of premier coup painting of the Irish scene. Painted on mounting board, primed with foundation white and using a mixed technique of brush, knife and rag moistened with turps, which I employed to obtain the cloud area behind the ruined tower. I limited my palette to Indian Red, Raw Sienna, Prussian Blue and Flake White. The foreground forms were dragged across with Vandyke Brown, straight from the tube (private collection)*

*Tint* A variety of a particular colour, for example, pale blue, pink.
*Shade* A gradation of one particular colour up and down the scale.
*Tone* Applied to denote value and express the complexion of a painting, i.e. high or low in tone.
*Harmony* Borrowed from music to describe a colour scheme in which nothing jars in tint or tone.

The following describe the merits or demerits of a painting as used by painters:
*Turgid* Thick or overworked brush-work, lacking life.
*Raw Colour* Lacking quality and refinement.
*Thin Colour* Poor in texture, lacking substance, diluted.
*Pretty Colour* Out of true harmony with Nature's coloration. Sentimental.
*Degraded Colour* To denote a muted or sombre colour scheme. In no sense dirty colour.
*Pitch* Another musical borrowing. A high- or low-key colour scheme.
*Chalky Colour* Hard, raw, crude.
*Foxy Colour* Hot, often the result of an over-fondness for Burnt Sienna.
*Chiaroscuro* The scientific balance of light and shade, in Nature.
*Premier coup/Alla prima* Direct painting and left untouched.
*Contre le jour* Painting against the sun.
*Trompe l'œil* Deceiving the eye so that what is painted is mistaken for the real thing. Largely discounted by contemporary painters.
*Underpainting* Preparation or foundation over which glazes and scrumbles are laid, used by the Old Masters.
*Glazing* Painting with thin films of transparent pigment over an under-painting.
*Scrumbling* If a glaze is not of a darker tone than the underpainting, it will result in a leaden opacity. Such a glaze is called a scrumble. Glaze colour tends to be warm, whereas scrumbled colour tends to be cool.
*Stippling* A process of painting by means of tiny touches.
*Lay-in* The first stage of painting. Foundation or underpainting.
*Monochrome* Painting in one colour, with the addition of white for light and shade.

## Colour charts

Much can be discovered about colour mixing by the making of coloured charts. They certainly should not be viewed as a task, but rather as an enjoyable and instructive form of training. Self-imposed study only comes to the student when he feels the desire as well as the necessity for it, and the importance of a colour chart is that you make it yourself.

Moreover, however good colour reproduction may be, printed

colours rarely correspond exactly to those we use out of a tube, and sometimes the discrepancy between the two is very perplexing, especially to the conscientious reader who is diligently following the text.

Now we know that when we mix a blue and a yellow together we get a green. But what kind of green? It surely depends on what kind of a blue we mix with what kind of a yellow. And, as I have already stated, Nature's greens are well known to be a stumbling-block to many students of landscape painting. In any chart, therefore, that you decide to make I suggest you first begin with green and see for yourself how many different shades you can obtain by mixing, for example, Prussian Blue with Yellow Ochre, then with Lemon Chrome, and lastly with Raw Sienna. Repeat the exercise, this time using Cobalt Blue, and finally Ultramarine. To all these mixtures Flake White can be added to make them lighter. More blue than yellow will make your green cooler, as an increase of yellow will make your green warmer!

The same revealing results can be obtained in producing different shades of purple. With three reds, Light Red, Vermilion and Alizarin Crimson in turn, mixed with your three blues, you will get many varieties of purple.

Grey is a colour that often baffles the student, so that he resorts to mixing Flake White and Ivory Black together. While this certainly produces a grey, it is devoid of life and colour. Now Nature's greys always possess a colour slant. They are seen or should be seen as – a bluish grey, a yellowish grey or a pinkish grey.

See what you can do, with your blues and your reds, your yellows and your one green, Viridian.

Experiment for yourself. A touch of this with a touch of that. I remember my delight when, by adding a touch of Vermilion to Cerulean Blue, I obtained that pearly grey which is at the base of all white clouds.

Only by such means will you learn how your colours can serve you, and by such discipline you will gain freedom.

## Great colourists

What do we mean when we say that a painter is a great colourist? Certainly we do not use the term of one who merely dazzles the eye with a pyrotechnic display of riotous colours.

In one sense a great colourist could be likened to a great orator. Both raise the tempo as well as the evocative quality of their subject. True, some oratory, like coloration, can sometimes cover up a latent weakness in the 'text', but when this power is properly employed on a sound foundation the colourist, like the orator, can invest his painting with an

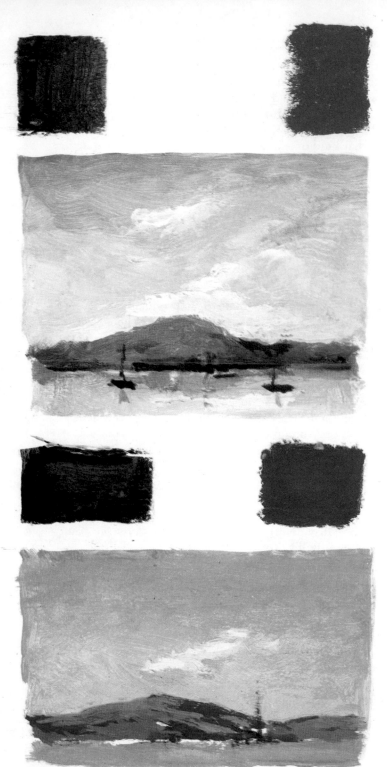

Red, white and blue is hardly a promising colour scheme for nature sketches, but I hope the examples here demonstrate the different results which can be obtained by choice of pigment and judicious mixing. In the top study, I chose Ultramarine Blue and Vermilion Red. In the lower sketch, I tried out Prussian Blue and Light Red. In both cases Flake White was introduced, without which it would have been impossible to render distance and atmosphere

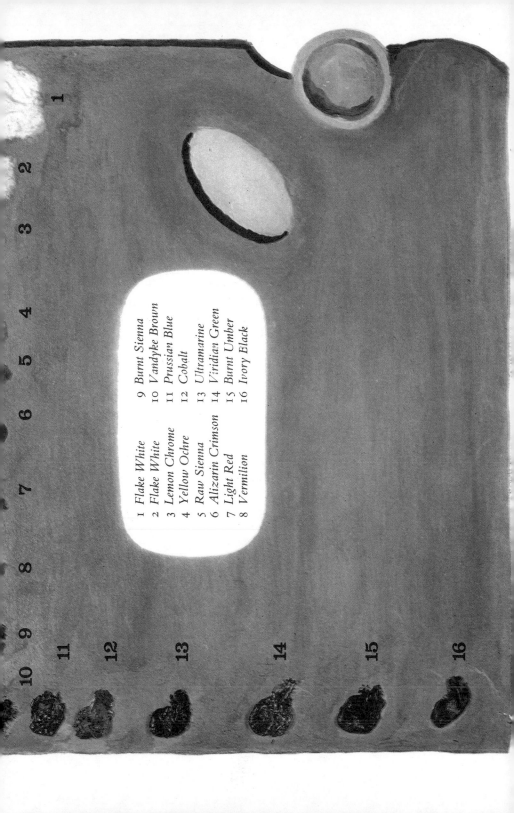

1 Flake White    9 Burnt Sienna
2 Flake White    10 Vandyke Brown
3 Lemon Chrome    11 Prussian Blue
4 Yellow Ochre    12 Cobalt
5 Raw Sienna    13 Ultramarine
6 Alizarin Crimson    14 Viridian Green
7 Light Red    15 Burnt Umber
8 Vermilion    16 Ivory Black

added sense of urgency and personal conviction. True, again, a great colourist may sacrifice the finer points of drawing and composition in order to give greater play to colour, in such a measure that we recall the painting in terms of its colour alone. In such cases his colours warm our memories as well as our eyes and kindle a sense of aesthetic exhilaration which in turn creates a feeling of sharing the painter's delight in the actual performance. Van Gogh, Ivon Hitchens and Ann Redpath immediately spring to mind. Without such artists' manifest exuberance, even to the pitch of exhilaration in the handling of their chosen colour scheme, the subject of their pictures would sometimes be of no great account. In the paintings of others it is our conviction that no other colour scheme could have exacted the same sensation of pleasure. In this respect, a low-toned painting, as in Redpath's interiors and still lifes, can possess all the thrill and pleasure that a highly toned picture may evoke, just the same as the minor key to the ear in music can equate with and, to some, even surpass, the major key in its melodic appeal.

These painters then can be said to be compulsive colourists. Colour in their hands is expressive of their intense conviction of its primary importance to their picture-making. They react (sometimes violently as with Van Gogh and Vlaminck) to the impact of colour; they see it with more intensity and display it with more vehemence. Moreover the actual physical performance, the impulsive sweep of the brush, is indicative of the emotion that drives them on. Such painters could be called pictorial extroverts. Certainly no retiring nature, no introvert, no orthodox or circumspect practitioner could possibly produce such exuberant, ebullient paintings. Time usually mellows their colours, causing them to glow rather than burn, but when first produced in all their pristine freshness, how Turner and Rubens must have delighted the eye.

With the Frenchman Rouault it is the richness of his colour, over which he had complete mastery, that we recall in his pictures. They glow and burn like sun through stained-glass windows and indeed Rouault was once a craftsman in this medium. He finally abandoned chiaroscuro and concentrated on involving himself completely in the use of colour. We benefit by such complete dedication to an ideal.

In much the same way another French painter, Bonnard, gradually departed further and further away from traditional colour relationships until his paintings became 'an ecstatic vision of the power and pressure of light'. It is said that he used colour with an eye for its supernatural power as a visionary painter might. 'His colour contained a strange organic sweetness as if it had been squeezed from flowers.'

Consider again what colour meant to Kandinsky, that great contemporary painter, who died in 1944. It is the chief element in his artistic language. We read that 'Kandinsky could not separate his earliest memories, his emotions, from the experience of colour. His spiritual world reached out into the material world through the medium of colour. For him, what he might have called the vibration of the objects of the outside world and the vibration of colours, sounds and words could not be divided.' (Wilinsky.) Painting and music were both interconnecting languages. We have evidence that he researched endlessly into colour to discover the psychic power of this material substance. In his studio, we are told, he had cupboards full of colours in neatly labelled bottles and he mixed them with the diligence of a chemist.

How then can we make a distinction between great painters and great colourists? Only perhaps by being conscious that both are often influenced by the country of their birth. Compare the paintings of the French Impressionists with the masters of the Dutch school of landscape painting. In the latter the landscapes of such great painters as Hobbema and Ruysdael could very well be summed up as 'cool to cold'. Here colour is kept strictly under control. Their pictures are lit by the light grey skies of Holland, relieved by patches of pale blue against which masses of brownish trees are strongly silhouetted. A darker blue is introduced into the mountain forms and deepens the trees in shadow in the middle distance. No positive or local colour is allowed to disturb the general climatic tone of the picture which preserves a serenity only to be properly appreciated by a comparison with the Impressionists' rendering of Nature in which all her colorations are given full play and local colour is fearlessly stated. Finally, of course, the difference is also one of temperament. Turner, for example, also Van Gogh, Gauguin, Matisse and, in a lesser degree, Derain, all handled colour with daring originality, liberating it from all representational restrictions. 'Their colour was intense to the limits of the colourman's resources, their handling a violent symbol of the painter's exuberant excitement.' All these are born colourists. I shall never forget the sustained thrill I experienced as, almost on tiptoe, I went from room to room in the Tate Gallery to feed on a veritable feast of colour offered by Kokoschka in his great exhibition of 1962 – the result can be summed up in his own words: 'Open your eyes, look and remember that this particular light, these exact colours and this unique gesture will never, never combine again. Nothing can hold this moment of life unless you seize it with your brush.' There speaks the great colourist.

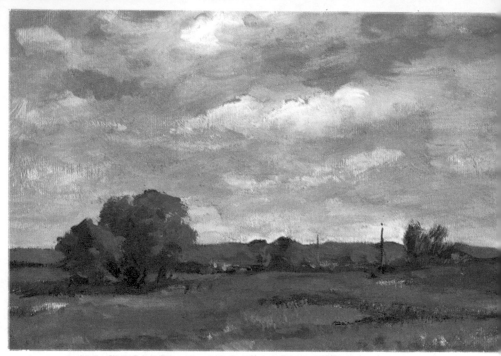

*Literal translation. Compare this with the treatment below*

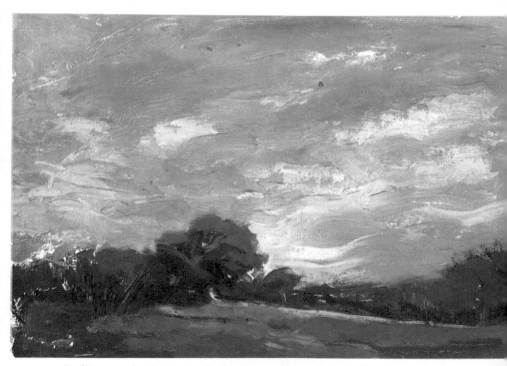

*In this example, the choice of subject was my own. The approach was romantic, the handling a mixture of brush and palette knife, swift and free from any obligation to copy Nature*

# 2 Composing the picture

Now whether we paint direct from Nature, or base our painting on sketches made out of doors, or whether we rely on memory alone, plus our imagination, composition plays a vital and indispensable part in each case.

The subject-matter may be simple or detailed, grave or gay; whatever the approach, drawing is the way we first plan, arrange or design our composition. So drawing comes first. In all painting, much depends on the subject-matter as to what will suffice for our scaffolding lines.

Charcoal is by far the best medium for our purpose. With it large areas can be shaded in with tone, while detailed drawing can be precisely stated by line. With a soft rag, charcoal can easily be dusted out and re-drawn until a satisfactory composition is obtained.

The drawing or plan, especially the parts where tone has been employed, should then be sprayed with fixative so that the subsequent washes of colour do not pick up the charcoal.

In the following diagram, a variety of suggested compositions are offered as a guide to the reader to see how these rules apply. Needless to add that there are many subjects outside this small range, in which case the reader must sort them out for himself, but I think they will all be found to correspond to the fundamental principles illustrated here. In every case, whatever the chosen subject, you will be building your subsequent painting on a sure foundation of *drawing*.

To compose is to arrange and put things in order. To be composed is to be calm and collected – as we say, 'to have everything under control'. To begin in a hurry, to dispense with a final check-up, 'to chance your arm' and hope for the best, will inevitably present real difficulties later in the painting. And remember that a truthful sketch drawn on the spot will always need a number of minor adjustments before it is ready to be translated into a painted picture.

Nature never claims to present the painter with a perfect composition. She offers herself, as it were, 'in the round'. You come across her from

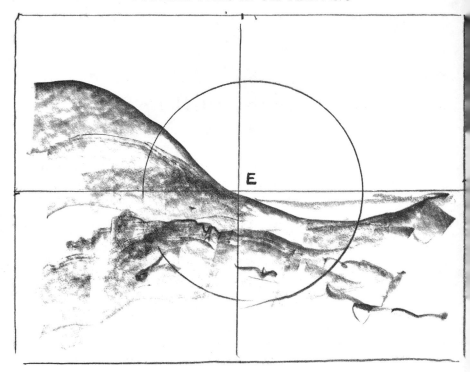

*When 'the eye' of the picture has been fixed, a few strong lines are sufficient to determine the composition*

various directions and in various moods, as fickle often as *she* is always referred to. And certainly we would not have it otherwise. While the photographer is strictly limited to announce what is there, we can rearrange, emphasize and modify to our artistic needs.

**Perspective**

In any book on picture-making, whatever medium is used, pictorial perspective, like composition, should have its place, although I admit that in much contemporary painting there is little evidence of its application and its principles are often treated with scant respect. Nevertheless, without it true recession, especially in landscape painting where distance is essential, is impossible to render naturally.

As I have in previous books in this series tried to explain how it can

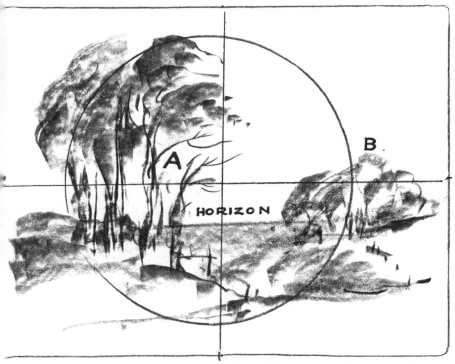

*Tone is necessary here so that balance is established between A and B groups of trees and between the areas of sky and ground plane*

come to the artist's aid, perhaps a word or two about a recent common mistake or misreading in a student's picture may not be out of place.

It is this: whether your picture is a high- or low-horizon composition, there is only *one* horizon line in each, and that line is always at eye level, whether we stand, sit, or lie on the ground. And it is to this horizon line that all parallel lines, of houses, walls, fences, telegraph poles, etc. will converge and meet at their vanishing-*points*, and it is important to note that not only may there be more than *one* vanishing-point but that it may be outside your picture plane (see diagrams A and B, p. 24). I have given two examples of the same subject, where the horizon line is a high one, and where there are *two* vanishing-points. In (A) the farm buildings in a high horizon are in correct perspective, while in (B) the perspective of the farm buildings is wrong.

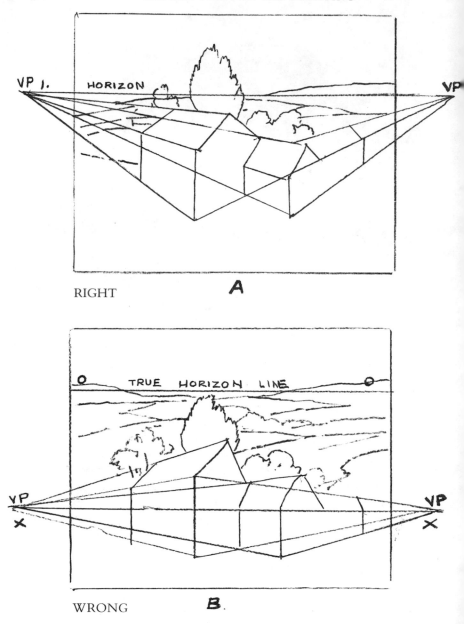

RIGHT **A**

WRONG **B.**

*A common mistake with perspective*

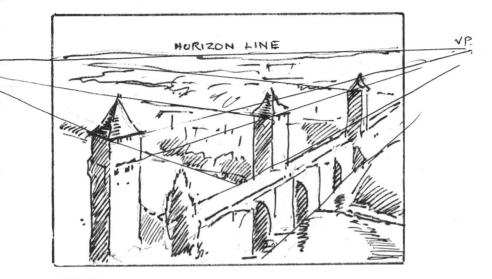

RIGHT

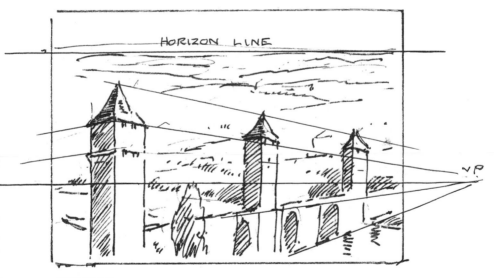

WRONG

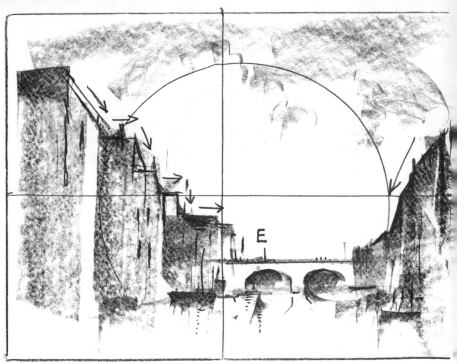

*Notice the difference in outline between the flanking buildings*

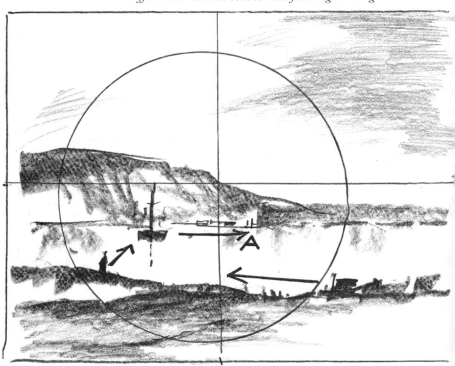

*The arrows indicate the direction lines across the water to 'the eye' of the picture*

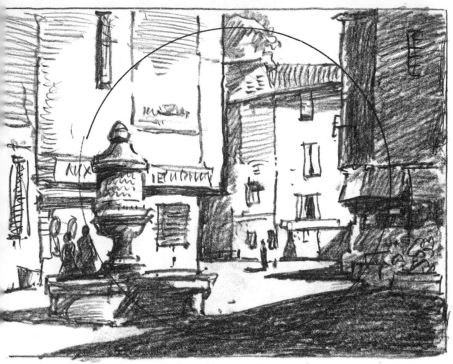

*Where strong cast shadows determine the composition.* (VENICE.)

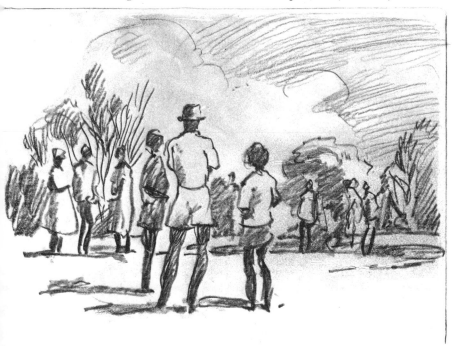

*The casual grouping of people suggests a figure composition.* (ZAMBIA.)

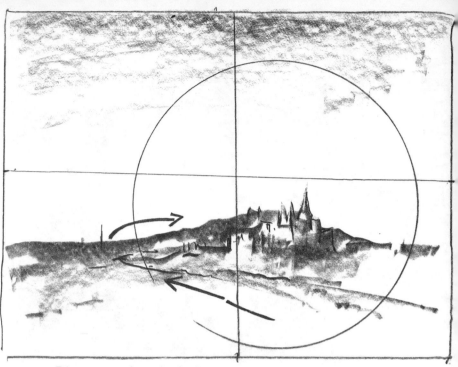

*Direct approach to the focal area. A stark subject demanding a sky*

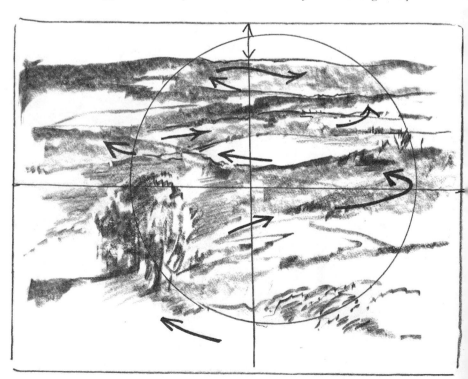

*A leisurely approach, via trees, lake, in undulating country, to a high horizon*

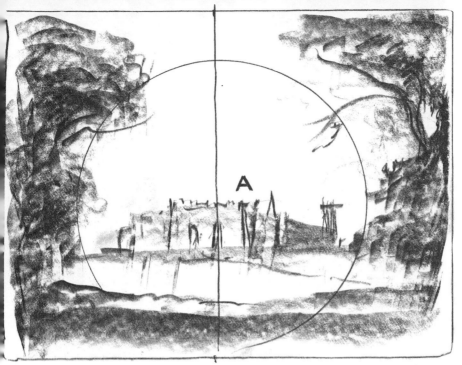

*Conventional composition in which the focal interest, a historic building, is framed by supporting trees and their shadow forms*

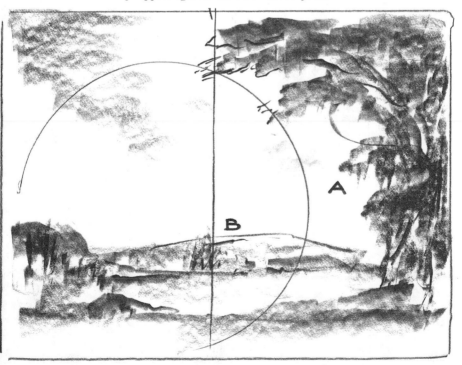

*Strong tree support A to achieve required recession of focal interest B*

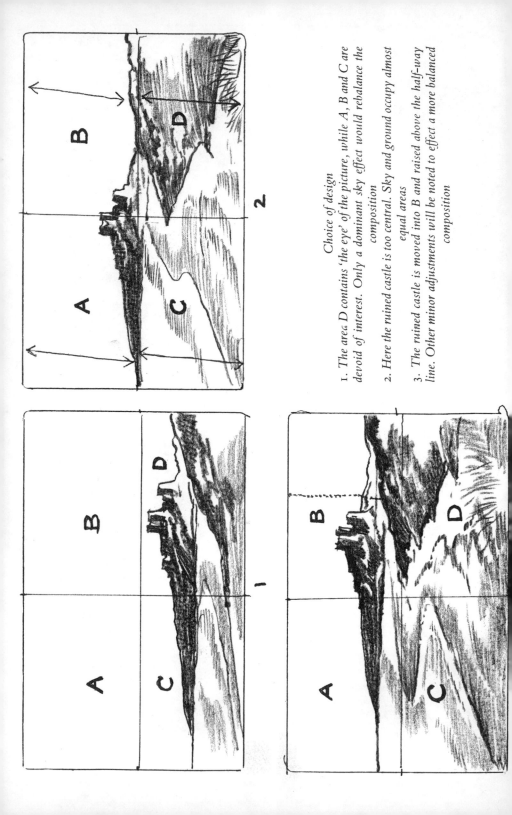

**Choice of design**

1. The area D contains 'the eye' of the picture, while A, B and C are devoid of interest. Only a dominant sky effect would rebalance the composition

2. Here the ruined castle is too central. Sky and ground occupy almost equal areas

3. The ruined castle is moved into B and raised above the half-way line. Other minor adjustments will be noted to effect a more balanced composition

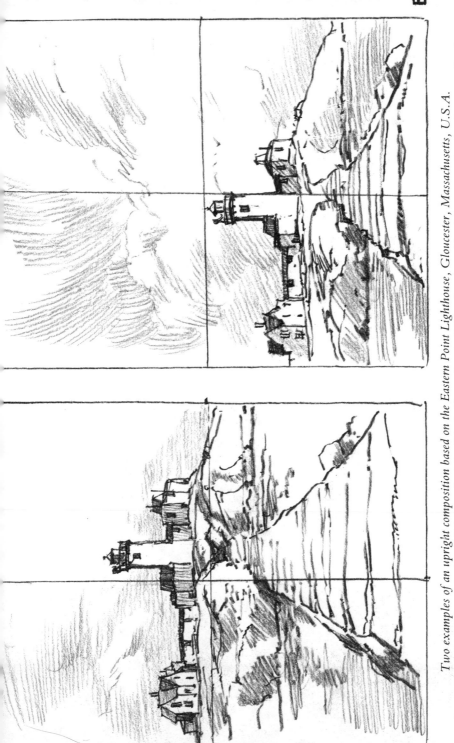

*Two examples of an upright composition based on the Eastern Point Lighthouse, Gloucester, Massachusetts, U.S.A.*

A. *Although the lighthouse is placed slightly to the right of the half-way (vertical) line, the composition is too conventional and too centralized*

B. *Here greater importance is given to the sky area, but the top of the lighthouse should have broken the horizontal line and taken the eye from the lower half into which the whole of the subject is compressed*

## On subject-matter

Once we have understood the full implications of a good composition, the question of subject-matter can be discussed more fully. Now anything, or practically anything, can be the motif of an oil painting. A home-made cottage chair, or a pair of outdoor shoes was good enough for Van Gogh. He suddenly saw their pictorial significance, he identified himself with the objects and the result was aesthetically satisfying.

In the same way the reader may decide on a haphazard arrangement in a corner of a room, on the floor, on a shelf above eye level. Any of these will make a good painting, but here it is important that we see the subject in the terms of a certain medium, in this case as an *oil*, for other subjects lend themselves better to water-colour, pen and wash or black and white, such as etching or a wood engraving. The subject in each case must be related to the medium; the matter and the manner must be resolved before we begin.

How often an oil painting would have been better as a water-colour, or vice versa!

Having seen our subject as an oil, the next thing to decide is the technique we employ and the paints we use.

*A chance arrangement can make a painting*

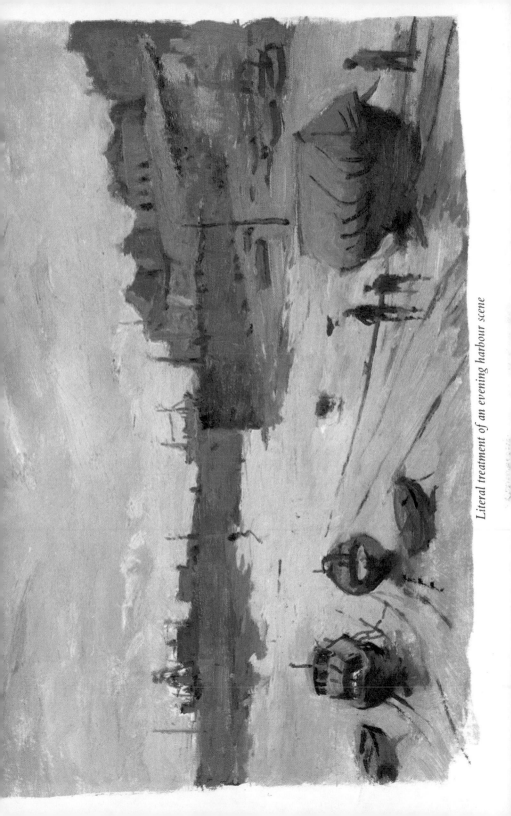

*Literal treatment of an evening harbour scene*

*Unusual setting for a figure subject*

### Colour in composition

Colour plays a more important part in the actual composition of a painting than may be supposed. It can establish the right balance of the design (irrespective of any atmospheric conditions) as it will be acting as a directive to the focal area of interest.

In some cases a good composition can depend on a single colour placed in the right position – or positions. This disposition of colours, the concentration of a mixture of two tints in a certain area, the echoing of one colour with another, the balance of warm and cool tints – such artistic devices can be observed from the works of many old masters.

But it should be emphatically stated that too much can be read into the restatement of such a premeditated policy of coloration on the part of a painter, which is in fact often purely intuitive, a subconscious reaction which can be said to be instructive and due to long experience rather than methodically thought out. Such analysis of a painting by conjecture and hindsight is a favourite theme with the art critic, and in some cases could be proved to be at variance with the painter's aims and can confuse

*Unusual composition suitable for the desired dramatic effect of this imaginary picture*

the issue with the inquiring art lover and can intimidate the art student.

Colouring can also be defined as the decorative part in the performance of a painting. Can it be accepted as a major attribute in assessing it as a work of art? This question arises when one considers a picture in which the colour is brilliant, sensuous or lyrical, but the composition and drawing may be noticeably at fault. Can colour in this case alone atone for a weakness in construction, however much pleasure we derive from its appeal to the eye? Ruskin goes to the other extreme when he states: 'No amount of expression or invention can redeem an ill coloured picture . . . if the colour be right, there is nothing it will not raise or redeem and, therefore, wherever colour enters at all, anything may be sacrificed to it.'

Be that as it may, we can all think of many examples of paintings in which colour is used more as an ancillary embellishment or decoration. In such cases we do not judge or remember the painting solely in terms of its colour, but rather for its majestic design, its heroic or romantic approach to the subject and its masterly drawing.

The overhanging
branches of the tree
and the local red
colour of the roof help
to concentrate the
interest on 'the eye'
of this oil sketch,
rapidly painted in a
corner of La Gaude,
southern France

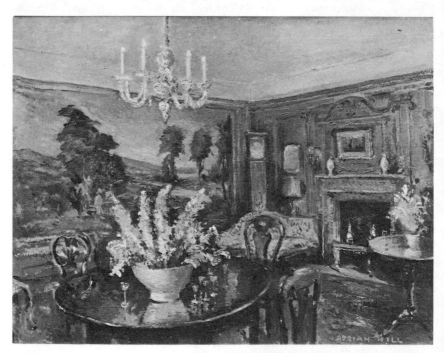

*Without the introduction of the flower pieces in the foreground and the large landscape
painting on the wall, the painting of this interior would have lacked colour and 'life'*

Colour, in such instances, can be truly said to play a part, but a supporting part, in our enjoyment of the picture. If the reader doubts the validity of this assumption, I can only remind him of many masterpieces which can prove fully satisfying in a black or white reproduction – especially as we may never have seen the originals. This applies to the works of many old masters, especially of the Dutch and Italian schools in foreign galleries, whereas many of the Impressionist paintings suffer lamentably when reproduced in monochrome as they rely as much on their colour appeal as on their subject-matter. This is the acid test. On the other hand, if the colour of a picture is monotonous or overworked, turgid or thin, no amount of drawing or soundness in composition can dispel a feeling of aesthetic disquiet.

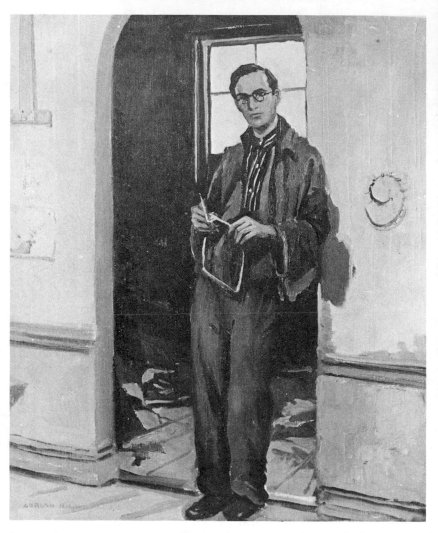

*In portraiture, an opportunity is offered in the setting. In this case the head is placed in its own 'frame', that of the window in the room behind*

# 3 Starting the picture

It is unwise in these progressive 'do-it-yourself' days to advocate any one way for the student to start painting. Over-eagerness to be off the mark often causes a false start. I know that, and yet eagerness, which is so natural, especially where painting in oils is concerned, must not be curbed by too many words of caution. Once the urge is manifest, it should be encouraged. In the past, students were taught to copy pictures of the Old Masters before launching out with original paintings, and even today, students both old and young can be seen in national galleries, emulating the principles and techniques of bygone days. I admit I never disciplined myself to undertake this exacting task, although I can well imagine that by so doing, many tried technical devices and accepted colour combinations are disclosed which may be of real service to the student on some future occasion.

What I think is important is freedom to *choose* the way you begin, whether you elect to take the plunge or proceed more cautiously step by step. One thing to my mind is certain, and that is to develop and enjoy the *feel* of oil paint, its texture, its flavour, its evocative power, its vital properties; and these can only be experienced and enjoyed when you have brush in hand and your pigments ready and waiting to be mixed.

One way of proceeding that I often recommend is first to draw in your composition with charcoal in the right proportions of earth to sky. A line across your canvas or board will settle that; it will, in fact, be the bare bones of a low- or high-horizon landscape. This line should either be roughly straight, suggesting the sea, or undulating, thus indicating the silhouette of hills against the horizon.

On this one scaffolding line you can begin to build up your composition. In both cases the introduction of a boat, a headland, a tree or a cottage, can come later. Your first concern is to cover the area of the sky with colour. From your blues select one and place a good amount on your palette, not anywhere, but as close to the edge of your palette as safety allows. Squeeze out plenty of Flake White a good distance away

39

*An upright tree composition, drawn in with a loaded brush, using Cobalt Blue, Vandyke Brown, R*
*Sienna and Alizarin Crimson. The highlights were 'lifted' with a small, dry brush, thus obtain*
*a variety of textures to relieve the weight of tone and the restricted area of sky*

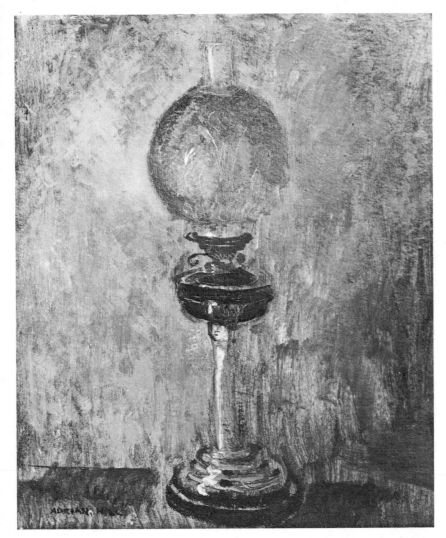

*A single object – in this case the Victorian lamp – was supported by a special technique,
especially noticed in the background, and carried throughout in a personal way*

and also on the border of your palette. Now with only sufficient turps to
soften your blue, and with a fully loaded brush, start painting across,
spreading the blue only so far as it will go; this will ensure that you are

41

*Another example of freedom in the handling of a single motif, which justifies its choice*

putting sufficient on to sense the quality and plastic texture of the pigment. If you choose Prussian Blue, only a touch should be introduced into your Flake White as the unadulterated colour is a very positive and intense one. I suggest Prussian rather than Cobalt or Ultramarine as it harmonizes better with Nature's greens. But the choice is yours.

As you proceed downwards towards the horizon line you will continue

to modify your blue by the gradual addition of more and more Flake White. You will have now covered a large area of your picture and demonstrated the dome of the sky, as by the time you have reached your horizon line your blue will be far lighter in tint and tone, which it is in Nature.

With another brush you can paint in your line of hills by mixing your blue with Light Red or Crimson Alizarin – both will give you a purplish colour. From the base of this band of purple start painting the ground area. Choose a yellow and add a touch of this with your blue, gradually increasing the strength of your yellow until you reach the bottom of your canvas, where your green will be far warmer in tint and show you just how warm colours advance, as cool colours retreat. A cloud or clouds can now be introduced, but if they are to be of a pure white, the surface blue of your sky must be dry, or dryish – otherwise your clouds will be a bluish white. The addition of some other feature, such as a single tree, the shape of a cottage or haystack, will help to break the flatness of your middle distance, and any vertical such as a tall tree, a signpost or telegraph poles in perspective will lend distance to your scene.

Incidentally, you will have been using no more than four colours: blue, crimson, red and yellow. The general effect, of course, will vary according to the particular blue, red and yellow you select. The illustration on p. 44 (*top*) I hope will give you an idea of what can be achieved.

You can repeat the exercise with a seascape, and if you vary the colour scheme each time, you will have gained quite a knowledge of how colours behave, and, more important still, how you can control their behaviour!

Armed with such knowledge, your first attempt to paint direct from Nature will be robbed of some of its fears and will be based on a firm foundation.

Another early exercise, but this time in *matching* colour, is to set up a very simple still-life group, such as an earthenware jug, a bottle and a fruit of some sort – apple, orange, grapefruit. Arrange them against a simple material background of one colour – don't choose a red – and don't bother too much with detail. The exercise here is to match as nearly as possible the *local* colour of your selected objects. Paint everything with a loaded brush – even though the texture is glass, and remember to put in the highlights last, especially on bottles for it is this accent or accents which gives a glassy effect and forms the shape of the bottle.

43

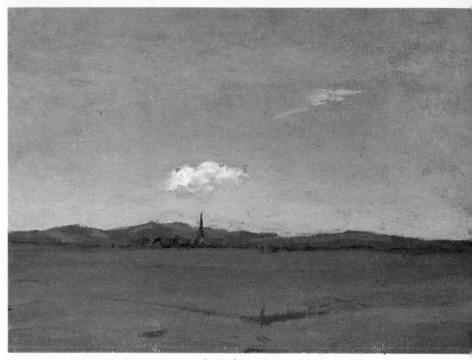

*An early exercise*

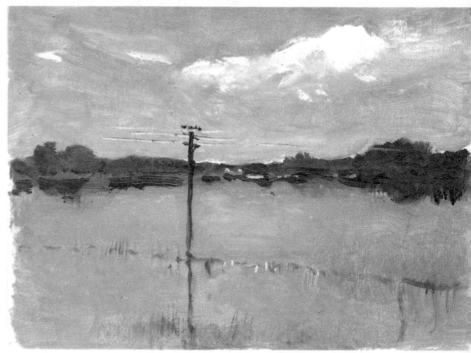

*The telegraph pole in a flooded field in the Transvaal, South Africa, made the motif and emphasized the desolate nature of the scene*

# 4 Painting under outdoor conditions

## Climatic conditions and seasonal difficulties

I realize it may appear a paradox if I start this chapter by affirming that one sketch direct from Nature will teach you more about the job of painting a landscape than any number of instructional stage-by-stage exercises done at home. Out of doors you will find yourself doing things, in mixing and in handling your paints, that you would not dream of doing indoors.

Nature will spur you on. There will be little or no time for vacillation or second thoughts. The result of your efforts may be – probably will be – wildly disappointing, but with all your blunders, near misses and clumsy handling, you will have *taught yourself* a lot of truths.

In fact, it is only when you are face to face with Nature that she displays her stock of available colours, tones and textures, and offers her wares for you to inspect and handle and, more to the point, gives you the option of a personal choice.

This is where the difficulty, or one of them, arises – what to select from such a fascinating range of hues when seen under a constantly changing lighting scheme. For we have already observed how colours change under the vagaries of day-to-day, or even hour-by-hour weather conditions.

Now if you are still unhandy with the tools of your trade, if colour mixing is still a mixed blessing, the promised pleasures of painting will assuredly be denied you. That is why in the last chapter I have advised that you only venture out into the open when you have done some homework first. It is necessary to be forearmed as well as forewarned against adverse weather conditions which, let us face it, often prevail in most countries. Although the weather may be set fair, the reader should be warned here that it is folly to paint on the *same subject throughout the entire day*.

Unless you are experienced, it is questionable whether you can complete later on in the day a painting in the same mood as you started it

in the morning, for the simple reason that the lighting conditions are all different, and, to be frank, you are not so painting fit as you were when you began fresh and keen some hours before. By all means, work at the same view as long as the light lasts, but let it be in the nature of a number of small sketches which can each be finished under the prevailing light, morning, afternoon or evening. In this case you can well repeat the same object throughout the day and you will be surprised to see how different the results are in colour and light and shade. Claude Monet spent a very profitable day in producing a succession of quick impressions of a haystack in a field.

Some painters, many perhaps, when painting out of doors start a landscape or seascape with the sky first. I do. I have for many years. To me, it is the only logical way of ensuring harmony between sky and ground. In other words, I accept the climatic conditions at the time of painting the scene, for what is happening in the sky will condition the colour scheme of the landscape underneath. There are some painters who are put off by the whiteness of canvas or board and prefer to work on a basic tint of some earth colour with plenty of turpentine, which provides a surface 'climate' into which they can paint; the basic colour adding body to their subsequent brush-work. Constable often painted into a thin foundation of light red, which can be seen in his brilliant 'on the spot' painting of Salisbury Cathedral from the river, in the National Gallery, London. There are no fixed rules, in fact. See if any of the opening moves that I have suggested appeal to you, and you will probably adopt one or find one out for yourself which will accord with your personality, and be found to work.

A great number of days in my working life have been spent painting out of doors, so if I appear to preach, I have had plenty of practice! I have known how unsatisfactory it is to paint under the direct glare of a noonday sun. I have experienced the reward of manfully struggling to paint in a high wind. I have once painted on until the light failed, with mixed results – a warning I have passed on above. I have endured the curiosity of many a passer-by – who takes a long time in passing – and have attempted, with less success, to ignore the inquisitive interest of a herd of cows. But when rain sets in, I always admit defeat and retreat at once!

Sketching holidays are generally planned for the summer months when it is hoped that the days will be fine, the sun temperate and the light steady. But it is doubtful whether paintings done under such ideal conditions match up in quality of colour and personal handling to those when

46

moving clouds play wantonly with light and shade, and a fitful breeze frets the smooth surface of water and tosses the massed leaves of a tree into a cascade of dancing lights, bringing life and movement into an otherwise static scene. It is on such days, when bright intervals succeed lowering clouds, that, if the challenge is met, such enterprise brings its own pictorial reward.

I would not be so emphatic about the promised merits of this bold endeavour if the results of my own outdoor painting had not proved to me that only by 'chasing Nature' can one (nearly always) pin down *something* of her elusive charm, which is more in evidence when the barometer indicates 'change' rather than when it stands at 'set fair'.

Obviously the winter months, if severe, are unpropitious for outdoor painting, but even then, given the right aspect from a window, a heavy snowfall accompanied by a freezing wind can offer a splendid landscape or townscape which can be painted indoors at ease and in perfect comfort!

Other inclement conditions, such as a heavy frost, damp mist or torrential rain, can all make paintable subjects in the sheltered warmth and dryness of a room with a view.

I am certainly not saying that painting out of doors is the end-all in producing the perfect landscape – far from it – but I do say that only by meeting Nature on her own ground will you be able to learn what she has to offer.

### The effect of light on colours in Nature

For many young students of landscape painting, Nature's greens can present a perplexing problem in their infinite variety, ranging from the bluest of greens of many conifers to the warmest of greens in many types of deciduous trees, from the icy shade of certain flower foliage to the sunniest tints of other types of vegetation. 'We all know that when we contemplate a landscape we do not see each colour independently, at its intrinsic value, but that all sorts of strange feuds and alliances are going on between the colours as they settle themselves in the chambers of the eye which result in an image curiously interwoven and interdependent – this colour being subordinated to that; another colour thrilling warmly in response to the attentions of a fourth and fifth and sixth.' And to make discrimination more precise, each individual or collective coloration is influenced by the prevailing light under which both react and which is continually transforming the original hue from the clear illumination of a morning sun to the benign radiance of a setting one. Moreover, with the orderly sequence of the seasons from early spring to late autumn,

47

another and even wider range of greens delights and teases the eye until the last trace of the pristine colours of spring days are dissolved into a rich glow of autumn's tints. 'Detach any one colour from the sweep of the sea, sky, field and shore, guard it with your hands as you look at it, so that it may be seen free from the interference of its neighbours and you will find that its "personal" tint is very different from that which it presents when you let your hands fall and the whole great company of yellows, blues and greens burst upon the sight at once. The actual intrinsic yellow of the sand is flushed almost to a flesh colour by the vivid green of the grass; the water beyond it deepens its blue to the glow of the beach and even the purple distance; the range of rolling woods is not without a secret influence which induces the whole orchestration to vary its tone some delicate degrees further.'

Notice, for instance, the particular shade of light yellow of a field of corn as first seen in the bright early morning sun; and as it appears, muted and cooled, when affected by an absence of sun or a keen wind ruffling its surface – to be later restored to its original warmth by the mellow rays of a late afternoon sun. More obvious are the occasions when the shadow of a passing cloud, like a magic wand, darkens the sparkling green of field, hill or dale, extinguishing its brightness and lowering it to a sombre hue with dramatic suddenness. In short, the strength and quality of tint and tone of all Nature's colours are at the mercy of weather conditions and submit to her according to her whims.

And remember, however pure and bright the actual local colour may be of a near-by object, when seen at a distance its strength is modified according to where it occurs in the landscape. A newly erected red-brick house in the middle distance will be seen to be considerably lowered in local colour. Again, by the very layers of atmosphere which intervene, a range of mountains at a certain distance comprising many shades of green will appear mantled in blue or purple.

'To see things through rose-coloured glasses' is self-explanatory both in respect of the effect produced by so doing and the metaphor implied by the performance. As a child I loved looking through the panels of coloured glass in my parents' conservatory, delighting in the contrasting effects produced by the tinted glass. How the blue, for instance, however sunny the day, magically transformed the bright garden to one of ominous and chilly aspect, only to be warmed beyond its normal aspect by viewing it through the yellow glass, through which, in reverse, an actually overcast day could be transformed into one of welcome warmth and sunshine.

48

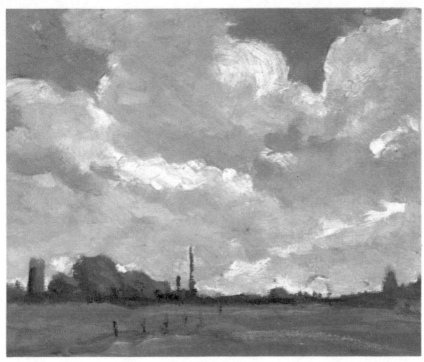

*Morning sky*

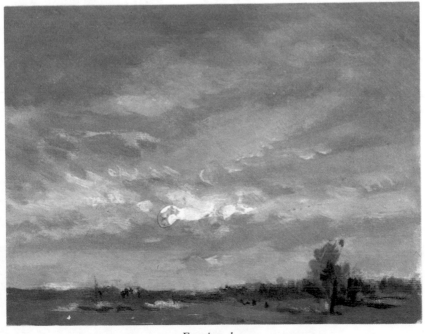

*Evening sky*

Much the same effects are being produced hourly by the agencies of sun and cloud from the sky above. For it is these elements which cause the manifold changes in the coloration of Nature's forms, and it should be remembered, all have their *own distinctive colour* and all derived from one or another admixture of the rainbow hues, yet all are governed by sudden changes in climatic conditions.

And all these differing shades of colour have to be matched according to our ability and personal approximation! For it is a fallacy to say that we can copy Nature's colours. We can certainly copy the colours of another painter's picture, but the luminosity of Nature's tints is beyond our reach when the very substance of our pigments is opaque and artificially manufactured. That does not, however, absolve us from striving after a measure of pictorial naturalism, but it does free us from a sense of frustration when our efforts at verisimilitude fail us. No wonder we ponder with increasing respect over this extraordinary element of colour. In sheer beauty colour stands alone, for no other kind of loveliness is so elusive, none so guarded by laws whose least infringement is visited with sterner or more instant punishment.

## Variations on a conventional theme

Continuing the problems of painting out of doors, I would like to take the reader to the banks of the River Test to share with me the following account of what I managed to do on a stretch of this popular fisherman's river, to which my host came armed with his rod and line and I with my sketching outfit. (*See pp. 52–54.*)

It was, as will be seen by my first attempt (A), an unpropitious day for painting. A monotonously grey overcast sky was threatening rain, the countryside was as flat as a pancake, the distant elms but regular solid clumps of dark green and only their reflections helped to relieve the colourless water of the river. It was as if I were viewing the subject through dark glasses. Was it really worth the trouble of attempting a picture? In the ordinary way I would have pushed on. As it was I decided to accept the challenge and see what I could get out of the subject by a series of quick sketches, illustrated here.

Accepting the view in each case, I made my second study (B) a high-horizon composition. By this device the strip of sky was no longer a problem, but the area of water was! However, reflections from the river banks and the distant trees helped to break up the mass of water as did some decorative waving river reeds which now came into my line of vision. I also realized that by moving my eyes (not my position) to the

right I could include a broken fence which would introduce a useful touch of local colour and interest. You see, I was already becoming a producer rather than a docile announcer.

My last two versions (C) and (D) which I just managed to rough in before the rain began were executed against time, but as I switched my eyes further over to the right and then to the left, I was able to add two more alternative compositions to those already executed. And this was, after all, the object of the exercise.

My palette for all four sketches was the same: Indigo Blue, Light Red, Yellow Ochre, Viridian and a touch of Lemon Chrome and Flake White. For any final painting I would certainly have added other colours, such as Raw Sienna, Raw Umber, another blue and perhaps Alizarin Crimson.

Incidentally, I was painting *contre le jour*, that is against the light (such as it was) or against the sun (if there had been any!). It will also be seen that I took little artistic licence, yet I hope I managed to produce four different aspects of the same conventional subject.

Having now been driven to seek shelter in a near-by fisherman's hut, I sat opposite the open door – the only means of light – and played with the idea of seeing if, from what was now visible of the river, I could fit the subject into an upright picture (E), (F). I could not, but what I did discover was the advantage of lowering my horizon line in my second attempt which with the help of a sky, would certainly have been more acceptable than the first try-out. In short, I was learning a bit more about my job, even if it appears that I was retracing my steps rather than taking further ones. And I hope the reader may sometimes think it worth while to follow my example.

May I just add that at the end of the day, while my host could only *indicate* the size of the trout which got away, I was able to produce *tangible* proof of my labours.

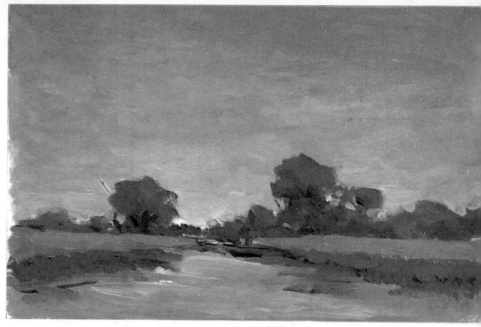

A. *As I first saw the subject, as a low-horizon composition. I was content to copy the view and match tint and tone correctly*

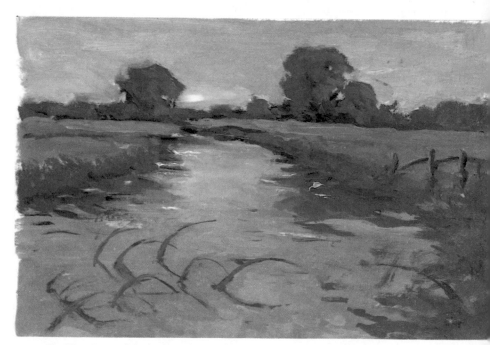

B. *Here I raised the horizon line so that the area of sky was as narrow as that occupied by the river in A. In both studies the colour scheme followed the weather conditions prevailing at the time*

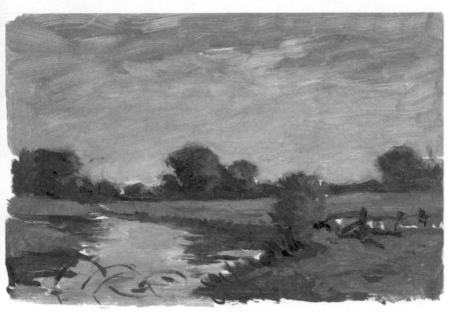

C. *A break in the sky decided me to lower the horizon line quite a lot but not as much as in A. By moving my eyes over to the right I was able to include a bush or shrub as well as the broken line of fence*

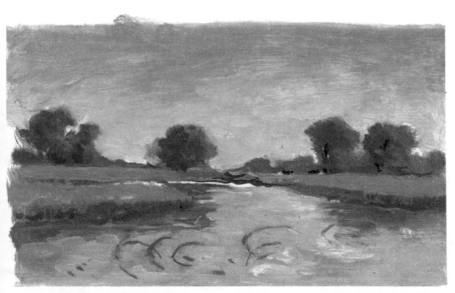

D. *Switching my viewpoint further to the left I gained another clump of trees. The rain now began, which forced me to quicken the pace of my painting, sacrificing any attempt at drawing in consequence. The four studies occupied little over an hour*

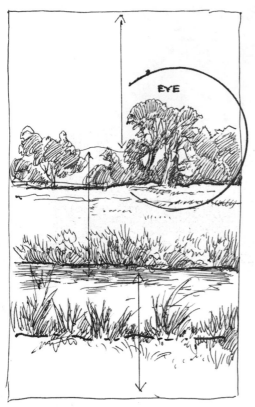

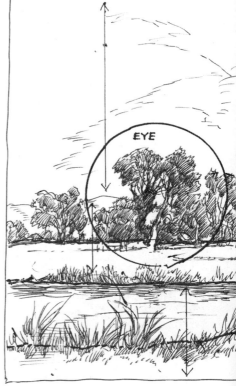

E. *As seen through the open doorway. The divisions of the sky, middle distance and foreground are too regular. 'The eye' of the composition is too high and too much to the right*

F. *A possible subject, after obvious corrections were made. A sky is* essential

# 5 Some tools

## The palette knife

Painting with a palette knife as an alternative to a brush can be a mixed blessing in the hands of the inexperienced beginner. It has without doubt a great appeal and for that reason alone necessitates some critical observations. Its sole use in any kind of painting will inevitably lead to a loss of precision in drawing and other niceties of necessary detail.

On the credit side, it helps to loosen up the handling of a timid worker and can recapture the first carefree rapture enjoyed by an eager student in the early stages. For any student who is afraid of using thick paint, the palette knife will enforce a bolder use of his pigments. This is all to the good, for you cannot paint thinly if you employ a knife.

It is like using a trowel and, in fact, one of its shapes is a miniature trowel, whereby the paint is mixed and gathered up from the palette as if it were cement, and spread lavishly on the canvas.

All eager and impetuous students vote that painting with a knife is 'great fun'. But to draw with a knife needs a practised hand, and it is best employed in open skies, and wide areas in the landscape especially when movement, sparkle and reflections are needed to render water wet!

Only in practised hands, however, can the picture be kept from an obvious display of technical virtuosity, that dread felicity which excites our admiration – or even envy – by its very manual dexterity. Indeed, a palette-knife painting can provoke a feeling of ambivalence, an equal regard and distrust of its popular appeal. As a well-known painter confessed to me, 'You can get away with murder with a knife – a palette knife, I mean.'

But there is no doubt that, like an instrument in the brass section of an orchestra, it can come in at the right time and in the right place with tremendous effect.

I have used the knife to convey the moment of impact when a heavy sea meets a rocky coast. I have introduced it to heighten the bright light under the dark rugged curtain of rain-clouds hanging low over the

*Example of rapid palette-knife technique on primed mounting board*

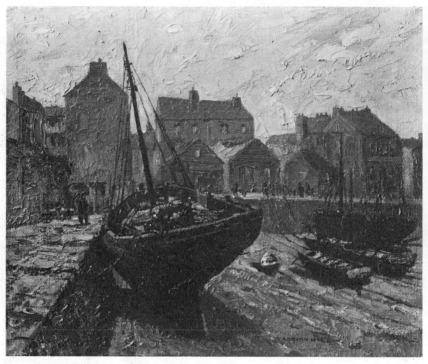

*A suitable painting for the palette knife, which was employed throughout.* (BRIXHAM
HARBOUR.)

horizon, in the highlights on foliage and foreground vegetation and on
surfaces of buildings that catch the light. It is, in fact, *in parts* rather
than all over the picture that the knife is best employed. It should be
added that highlights on glass and metal, on any surface that reflects
light, can be achieved with precision and subsequent reward by a deft
touch with the side of a knife. Nothing can so enliven a passage which
has become sluggish in handling than a clean, swift stroke of a knife. A
confident sweep or a flick with its flexible steel can resuscitate a moribund
painting and cause it to become alive!

I have found, however, that it is always a relief after a concentrated
spell of palette-knife painting to return to the brush, with the conviction
that whereas the former can be likened to a useful *weapon*, the brush
remains the best all-purpose tool for painting.

### Coloured pencils for reference for oil painting

Whether you are seeking material for a landscape or for an interior

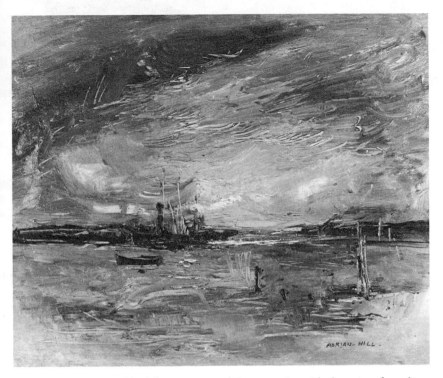

*The effect is heightened by lifting portions of the wet paint with the point of a palette knife*

subject in oils, such reference should be found in your sketch-books which can be retained for this use.

As I have written elsewhere and at some length on the importance of such preliminary studies and of the various techniques which can be employed for the purpose, it is only necessary to draw attention to a more recent medium, that of coloured pencils, which I have found handy to carry, easy to handle, and which give adequate reminders of local colour which can be closely followed when painting.

Black and white sketches with notes of colours written on the drawing, such as 'dark brown', 'warm green' or 'silvery grey', I have found mean little or nothing when it comes to reviving visual memories of the original colour scheme.

Moreover, a coloured study or 'rough' with a wide choice of tints can be executed almost as quickly with the pencil and does not require fixing.

Two examples will be found on page 60.

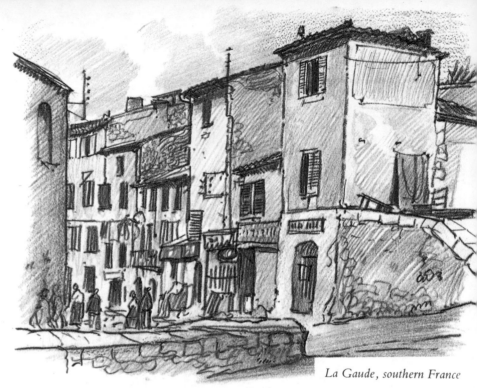

*La Gaude, southern France*

*Two examples of sketches where coloured pencils were of great help for quick reminders of local colour and as a reference for later paintings in oils*

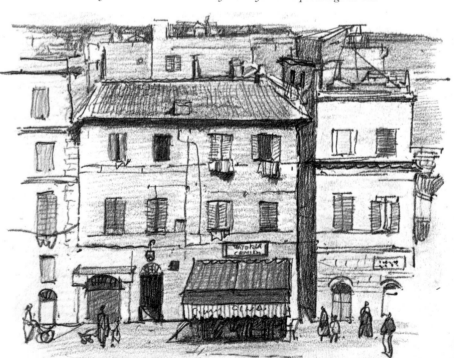

*Nettuno, Italy*

# 6 Timely warnings and students' questions

## Painting over a previous picture

If you wish to paint a new picture over a previous one which has not 'come off' (as all of us have had occasions to do) never paint directly over the original.

First you should sandpaper the surface down to a level smoothness all over, especially if the original painting was executed with a palette knife.

Next a coat, or even two, of foundation white should be spread over the canvas or board and left to dry out.

On this surface you can now confidently paint an entirely different picture without any danger that ghostly shapes of the previous picture will appear, which can often happen if you have not taken the above precautions.

I remember seeing a painting in an exhibition of a summer seascape which was ruined by the faint skeleton form of a winter tree, which had obviously been executed with a palette knife, growing out of the water.

In the same way, if you choose to paint on the back of a former picture, first see that the original is thoroughly obscured by a couple of coats of the above flat white, as it can be slightly embarrassing to find you have offered the purchaser two paintings in one frame.

Although SX lining board and hardboard, when primed with emulsion white, are entirely satisfactory for most landscapes, for a commissioned portrait canvas is generally preferred by the client.

## Keeping the palette clean

There comes a moment in the course of a single painting when one finds that every available inch on your palette is covered by some colour mixture. This is the time to stop and clean up, especially if you are on the point of returning to the sky portion of your picture. The remains of any earth colour mixtures of green, yellow or brown can easily be picked up by brush and ruin the sky.

We all may dislike this interruption but I have found it always pays. Not only clean your palette, but rinse through your brushes with turps. The majority of dull, dirty and turgid paintings are due to this neglect of a 'wash and brush up'.

And always see that any new colour you put out goes back to the same position occupied by the original pigment. This will ensure that your Flake White, for example, will be pristine white and not 'off' white, which it will be if you squeeze it on or too near some other colour. And, by the way, cleanse the inside of your dipper occasionally as this, too, can become encrusted with drying paint, for clean turps is quite as important as clean brushes and a clean palette.

### Finishing a picture

To a student's question, 'When can you say your picture is really finished?' I once made a somewhat facetious reply: 'When it is well framed, well hung in a public exhibition and has a red star on it.'

Seriously, it always remains a moot point when to 'down tools'. Quite apart from the actual size of the picture, the length of time taken over the painting of any subject depends as much on the nature of the artist as that of his subject: whether you are a quick or a slow performer. While an impressionistic painting direct from Nature demands speed of execution, a produced painting built up from studies and implying greater finish necessitates a more deliberate approach and handling. But in both cases the time taken is a question of whether the impression or the more finished production is coming on as you desire, for both can be completed in one sitting. But a *premier coup* painting is really only applicable when working out of doors and when you are striving to capture a passing mood of Nature. And while a couple of hours can be sufficient, say, for a 24 by 20 in. painting, it may take more than one sitting if things go wrong.

If your progress is held up by having to repaint some portion of your picture or rescue some faulty piece of drawing, or worse still, if you are suddenly in two minds as to whether your technical approach and handling is right for the subject, then your painting may continue 'on the stocks', as we say, day after day and for weeks on end.

When to stop, then, is wholly a matter of experience. Certainly the painting that is finished in 'one go' can have the edge over one that shows signs of labour in gaining the same result, for an overworked picture generally bears the imprint of the stress, strain and toil implicit in its execution.

Over-elaboration, a beginner's failing, often results from over-conscientiousness. Finishing touches which the student hopes will enhance his painting and make it even better often rob his picture of vitality and lessen the beholder's pleasure by having his attention diverted to meticulous detail.

It often happens – anyhow, in my experience – that a near 'finished' painting can still appear to lack something – some accent, or incident which would pull the picture together and provide the *raison d'être* for painting it. My advice in this case is to remove your picture from sight – place your canvas with its face to the wall and for the time being forget its existence. After an interval, put it again on your easel when you will see it with *a fresh eye*. For it is then that you should be able to spot what it lacks, as you will now be in the position of the *observer* and no longer as the prejudged *performer*. Sometimes, of course, you will decide, especially if you put it in a frame, that it needs no further work. The point is that the fresh eye will decide the issue.

'It happened to come very easily.' That remark can often be heard when one painter is showing a 'brother brush' his latest effort. Not so often, I suspect, as 'It's been a real struggle, but I think I've pulled it off.' I've said this so often, to myself!

## Backgrounds

'I have great difficulty with my backgrounds; how does one make them go back?'

To this naïve question – which I've often been asked – one is tempted to quote the apocryphal retort of Turner's: 'I keep saying, "Go back, Go back."' Certainly it would appear that his demand worked like a charm!

Of course there is no one formula for backgrounds, any more than there is for middle distances, or foregrounds for that matter. Each one represents a different problem and very largely depends on climatic conditions. Certain it is that to achieve recession, cool colours must prevail, for it is a well-known fact that warm colours advance.

Again, it is obvious that just as we don't see detail in distant forms in Nature, so detail in buildings, trees, etc. should not be overworked in our painting.

## Clouds

'How do I paint clouds?' is another despairing question. Except to say, as Turner might well have done, 'Go up, go up,' there is again no

golden rule, apart from the warning that if clouds are painted like solid forms – as they can well be if you follow their shape and design too closely – you will defeat your own aim of preserving a quality of movement and their distance from the earth, which will surely fail if you load your colour and paint too tightly.

Water, which has both transparency and movement, gives you similar problems to contend with, and both these qualities will suffer if you overwork your colours and thus restrict the freedom of your brush-work.

But, of course, only by studying Nature and observing, at first hand, how she *behaves* under certain conditions, can you understand and present her way of life. Armed with this knowledge you can hopefully expect a reward for a personal painting.

*Care was taken to lead the eye to rest round the window, broken up by the encroaching forms of drapery and surrounding bric-à-brac of the store shed*

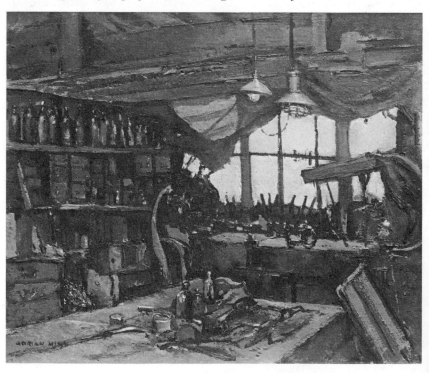

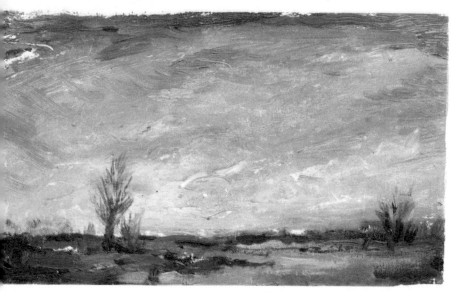

*Two experimental 'try-outs' of the long horizontal composition*

A. *A very low-horizon evening scene with the stark silhouette of the dry tree, leading the eye up into the sky*

B. *An even longer horizontal shape with the massive tree form to prevent the eye from passing across the picture*

*Both studies were painted with a restricted palette of Light Red, Cobalt Blue, Raw Sienna and Ivory Black, on mounting board*

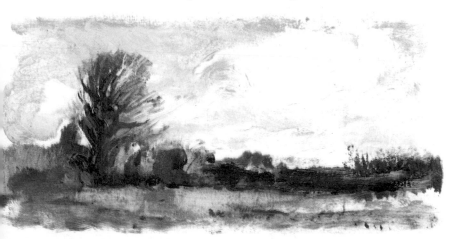

# 7 On framing

An unframed picture has been likened to a monarch without his crown. We know what is meant. Certain it is that no professional artist would dream of showing a painting unframed. And the frame should show off the work to the best advantage.

I have already advised having a stock frame available for determining the amount of finish or detail that may still be required and which without a frame is difficult to visualize. Now I am warning the reader that while one style of frame can enhance a painting, another can kill it dead.

The art of framing has improved greatly, but only reputable picture-framers with a selection of mounts and mouldings can demonstrate the value of choosing the right design for a particular painting.

Contemporary paintings – and we wish our pictures to be such – can be ruined by old-fashioned frames which we may possess and which we hope will do by treating them with this and that. Remember that the potential purchaser sees the picture and its frame as *one*, so it is to the artist's advantage that the frame, as has been suggested above, 'crowns the effect'. Canvas mounts and 'tray' mouldings, tinted surfaces and metal slips are only a few of the modern improvements in frame design.

Framing your picture behind glass is a purely personal matter. Some painters, I know, dislike it on account of the reflections which appear of the viewer or the wall or window opposite the picture which can certainly get in the way and prevent a clear view of the painting itself.

On the other hand, some painters favour glass as they say it gives the painting an added quality, a subtle refinement, as well as protecting it from dust, etc.

One distinguished oil painter whom I know will never show a painting without glass and even, I'm told, has a directional slip on the back of the frame forbidding its removal!

A non-reflective glass is now on the market which tries to please both

parties, but in my opinion only gives the picture the curious look of a colour reproduction.

With the introduction of air conditioning into our public galleries, glass is being removed from all the Old Master paintings.

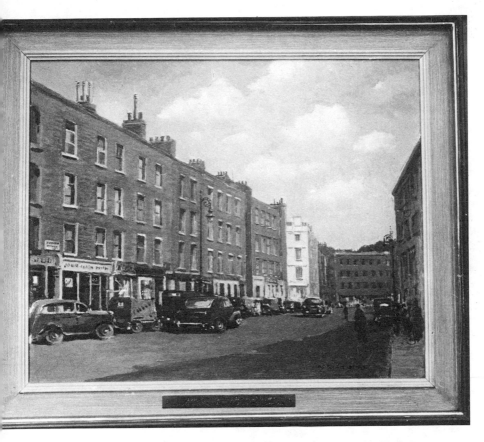

*The author's painting of Blandford Street, London, from which Blandford Press derived its name. This contemporary tray frame, with an inset canvas mount, is suitable for a street scene subject*

67

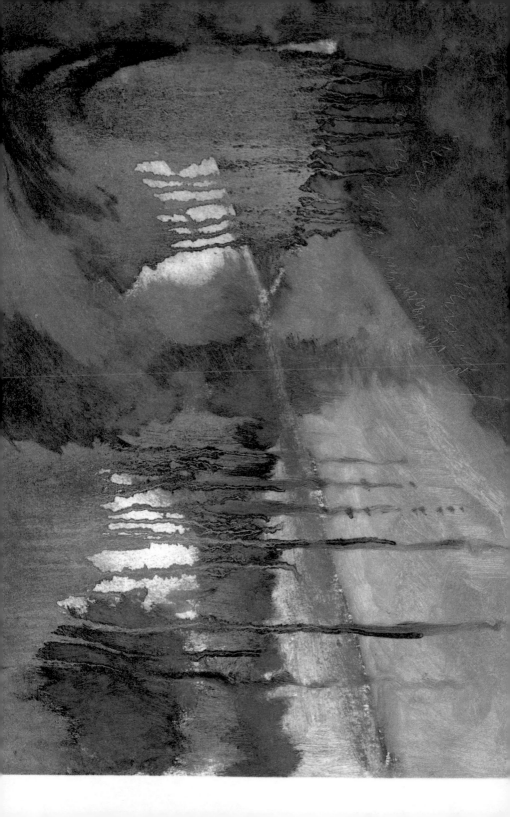

# Conclusion

'Typical amateurs', writes William Gaunt, the distinguished art critic, 'tend to be a little uncertain about aim and ability, awed by professional accomplishments but wishful to arrive at a professional result.

'They search through the handbooks of instructions for correct recipes of colour mixing, rules of composition, ways of attaining accuracy in perspective and making objects look realistically like.

'Quite often they are able to profit by the hints and tips of the skilled practitioner.'

If I have been more concerned in a book of this nature to encourage the reader to make his own discoveries and stimulate inquiry, it is because I am persuaded that in the end it is the empirical way, that of trial and error, that provides the greatest sense of achievement and satisfaction. What can be passed on are truths rather than rules. For I am reminded that my readers can be roughly divided between the 'do or die' and those that favour a step-by-step advance, the impulsive and the circumspect. Both have my sympathy and respect, and both, I hope, have been catered for.

Finally I would leave this comforting thought with both kinds of reader whose progress is fraught with 'near misses': 'To banish imperfections is to limit exertion, to destroy expression and to paralyse vitality.' (Ruskin.)

◀ *The Quiet Stream (private collection)*
*The subject offered a variety of techniques in handling as well as in colour. A lavish use of turps for brushing in the trees caused the stems to take their own shapes and set the tempo for a romantic setting. Prussian Blue, Raw Umber, Terra Vert and Light Red were sufficient for my purpose.*

# Acknowledgements

The reproductions of paintings by El Greco (p. 6: *View of Toledo* – the Metropolitan Museum of Art, New York (bequest of Mrs H. O. Havemeyer, 1929) and Van Gogh (p. 8: *Autumn Landscape with Four Trees* – State Museum Kröller-Müller, Otterlo) are from the Blandford Art Series, and are reproduced by permission. The frontispiece photograph is by Charles White.

# Other Blandford Books by Adrian Hill

### What Shall We Draw?

'In this book, as in television programmes, Adrian Hill stimulates the reader in more than just desire for craftsmanship. He asks us to see things as they really are, and then to portray them. In easy style and clear steps, the book unfolds some of the fundamental stages in sketching.' *Health Education Journal*

### The Beginner's Book of Oil Painting

'A very practical approach to the subject by a master of the craft. . . . Throughout this book the reader is encouraged to be himself and to try his own experiment . . .' *The Schoolmaster*

### The Beginner's Book of Watercolour Painting

'The information given, whether it concerns brushes, colours, equipment or technique, is always absolutely sound, as is his insistence on a personal approach. The illustrations are a joy.' *The Schoolmaster*

### Knowing and Drawing Trees, Book 1

'Anyone with an appreciation of natural beauty will find this small though beautifully produced volume a delight to possess. Adrian Hill has the technical skill of a first-rate draughtsman plus the selective perception and good taste of a first-rate artist.' *Art News and Review*

### Faces and Figures

'Full of extremely valuable practical hints to the aspiring craftsman, and the text is embellished by excellent illustrations and diagrams.' *London Head Teacher*

### Sketching and Painting Out of Doors

'This small but beautifully illustrated book should appeal to the amateur and professional alike. To the former for the mine of information it gives: to the latter for the deep sincerity with which it is offered.' *Arts Review*

### Drawing and Painting Flowers

'A concise account of flower painting through the centuries is followed by sound advice on the painting of flowers in both oil and watercolour. There are fifteen colour plates and numerous monochrome reproductions of pencil drawings delicately delineated.' *Times Literary Supplement*

## How to Paint Landscapes and Seascapes

'Adrian Hill develops his theme to show how individual choice and presentation of subject, allied to respect for the raw materials of his craft, can lead the student to paint with deeper perception and feeling.'

*Art and Craft Education*

## Drawing and Painting Architecture in Landscape

'The value of this delightful book also lies in Mr Hill's beautiful and explicit paintings and sketches. It is a great help to artists and art students.'

*Time and Tide*